Kittens, Kittens All Around!

Kittens, Kittens All Around!

Written by
Peggy Schaefer

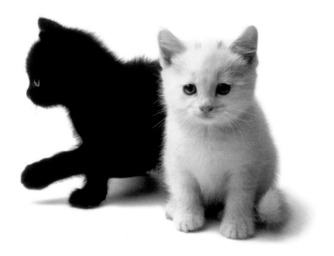

Ideals Publications • Nashville, Tennessee

ISBN 0-8249-5888-8

Published by Ideals Publications
A division of Guideposts
535 Metroplex Drive, Suite 250
Nashville, Tennessee 37211
www.idealsbooks.com

Color separations by Precision Color Graphics, Franklin, Wisconsin

Printed and bound in Italy by LEGO

Designed by Marisa Calvin

Front jacket photograph: Pat Doyle/Corbis
Back jacket photograph: Bob Shirtz/SuperStock
Jacket flap photograph: Vic Pigula/Alamy

1 3 5 7 9 10 8 6 4 2

A meow
massages
the heart.
—Stuart
McMillan

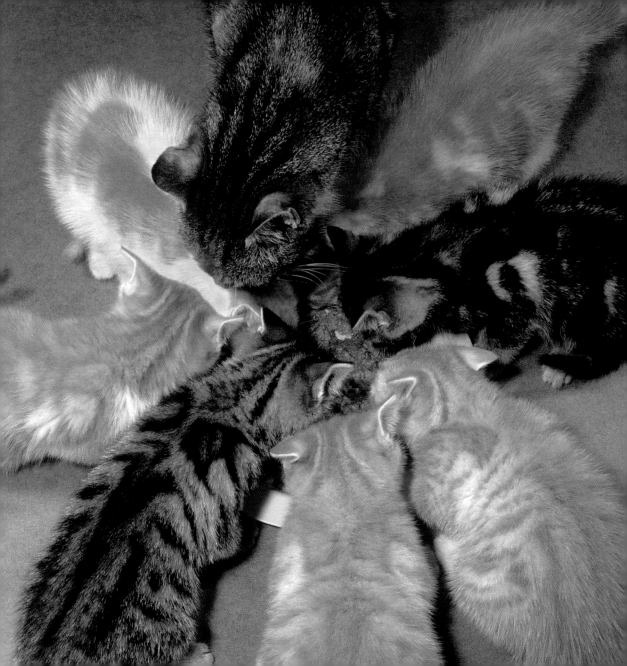

kittens, kittens all around

they perch

in trees;

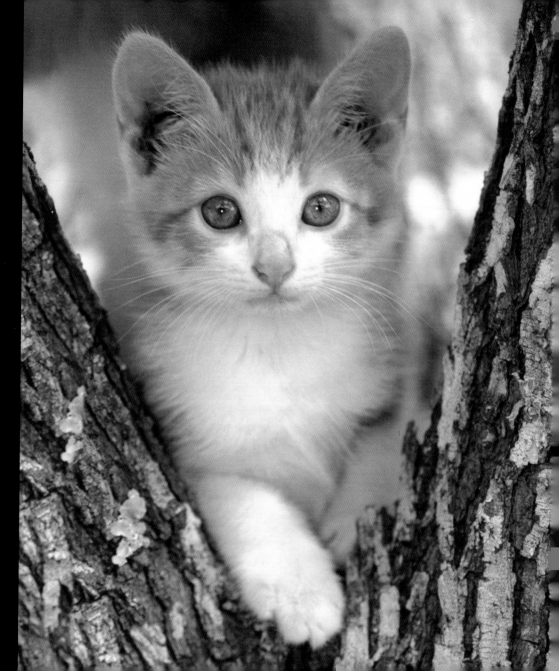

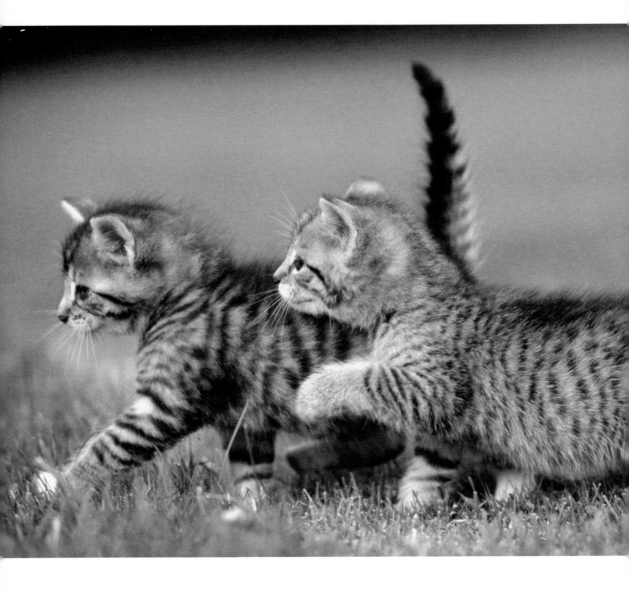

they roam the ground.

They

might

be

striped

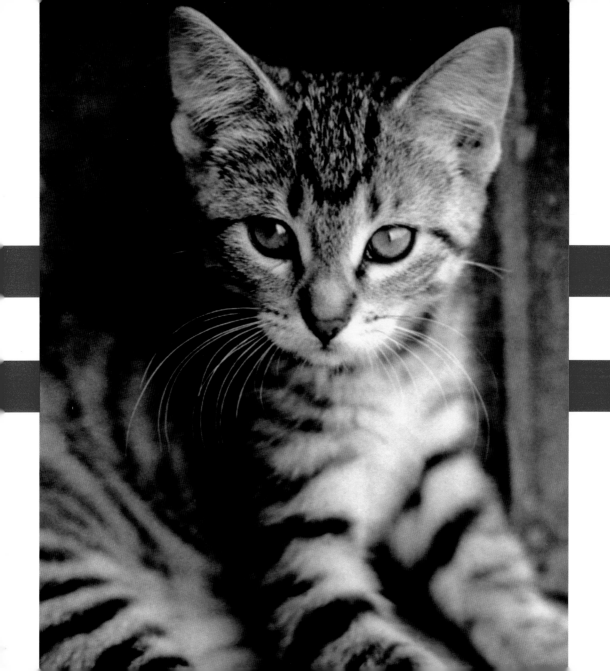

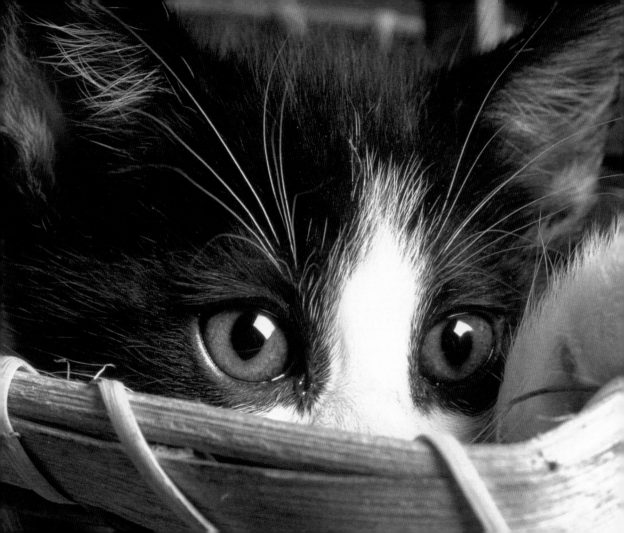

or BLACK & WHITE.

Some are friendly,

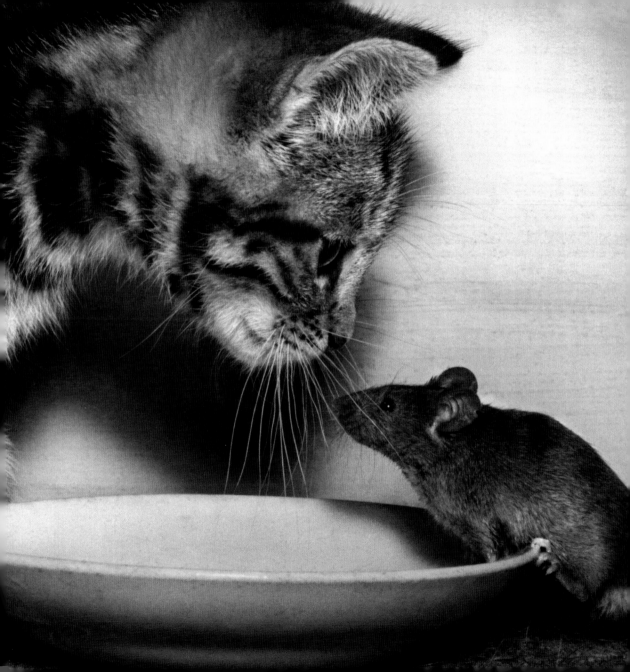

and some will

fight.

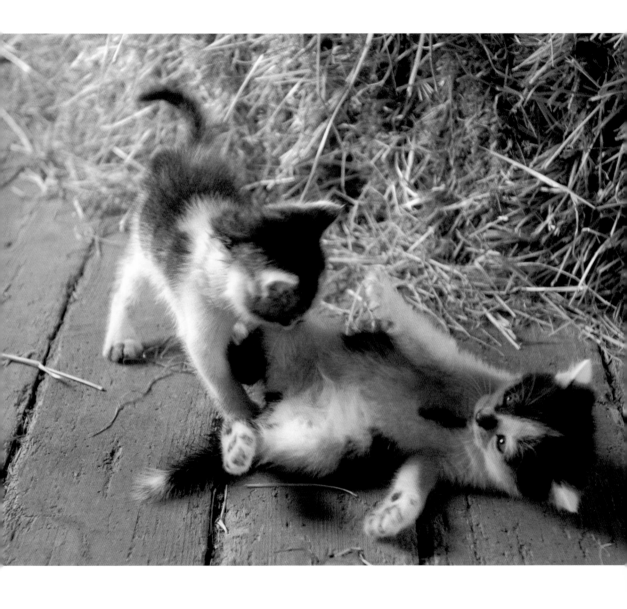

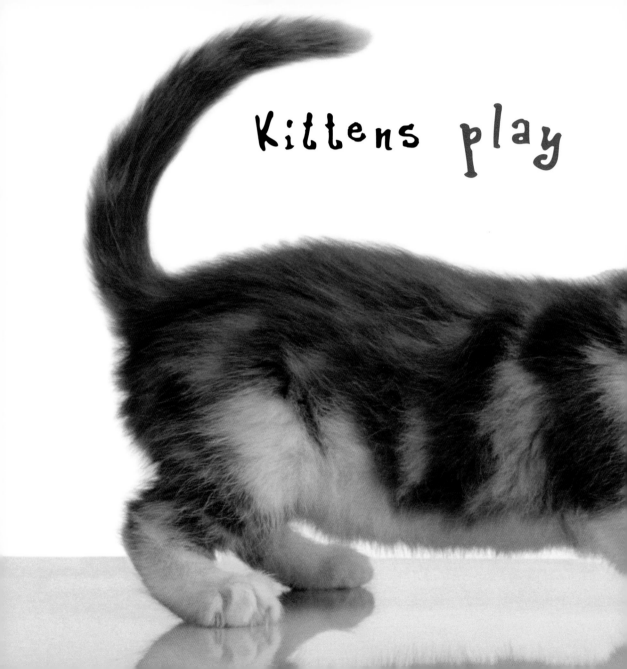

Kittens play

and kittens choose

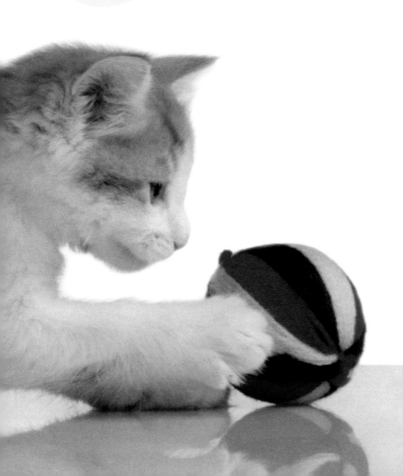

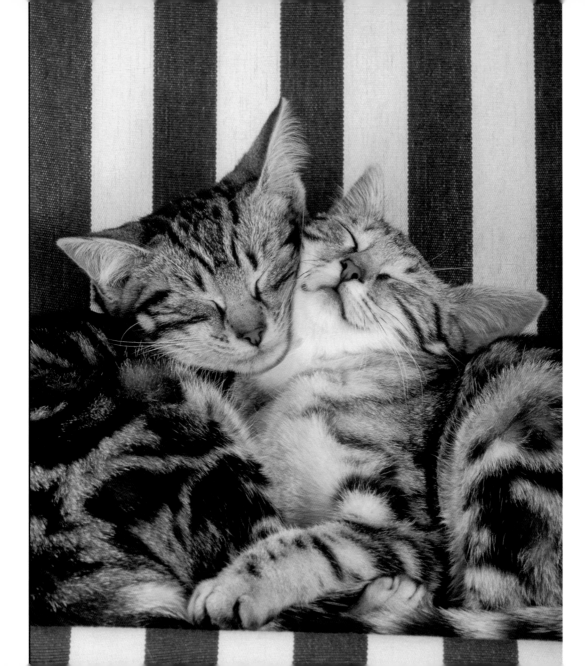

where they'll plop
right down to snooze.

Walking fences,

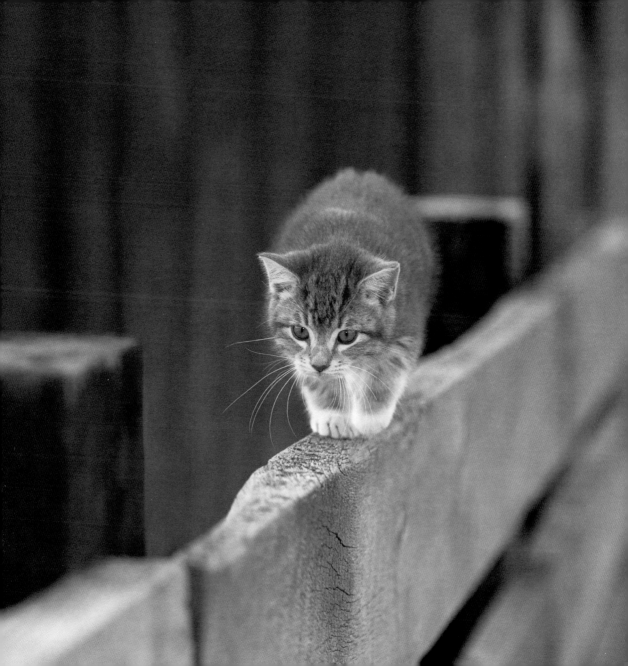

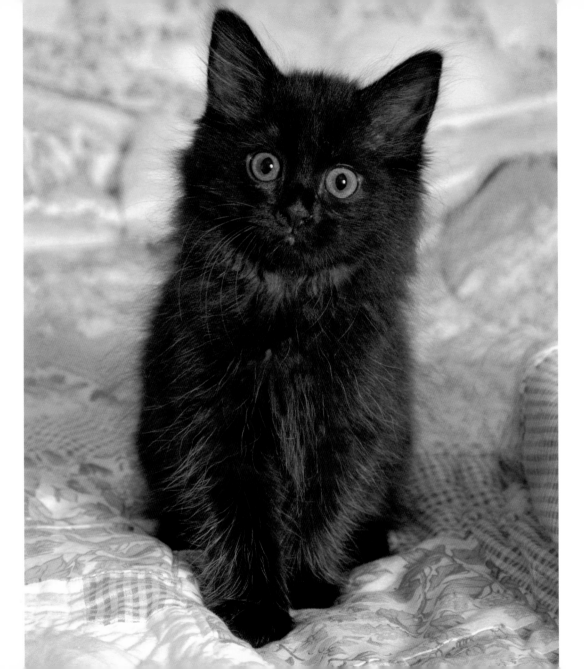

sitting
tall,

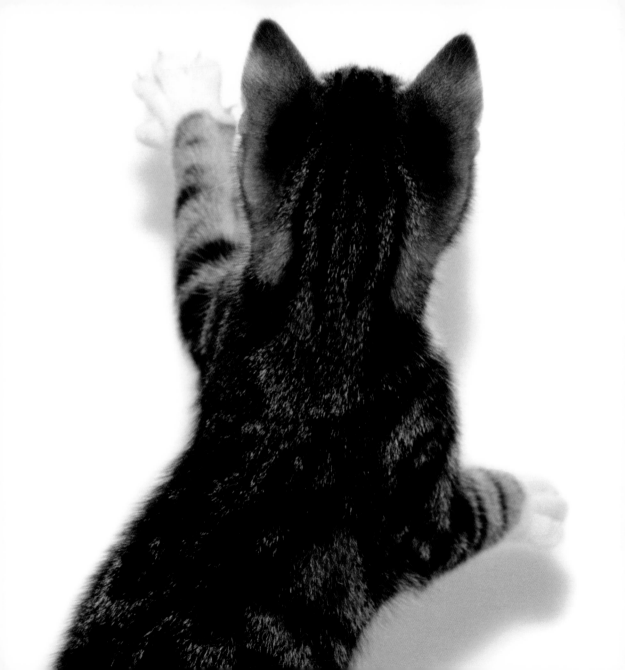

chasing
shadows
on the
wall.

Long hair,

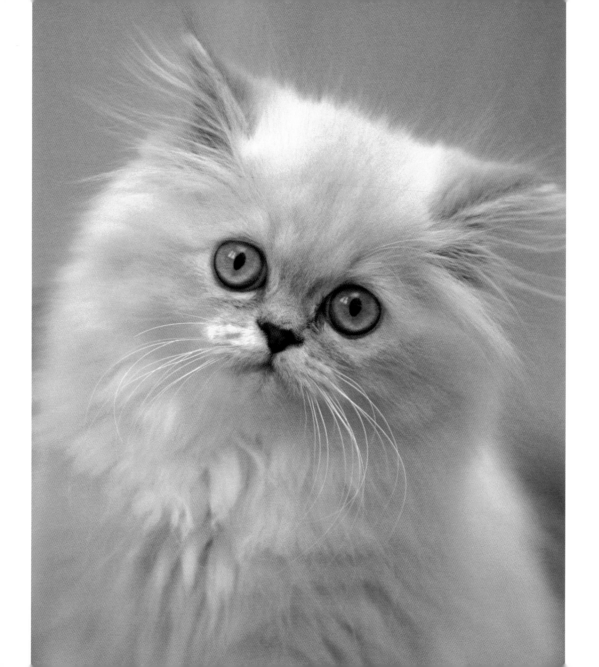

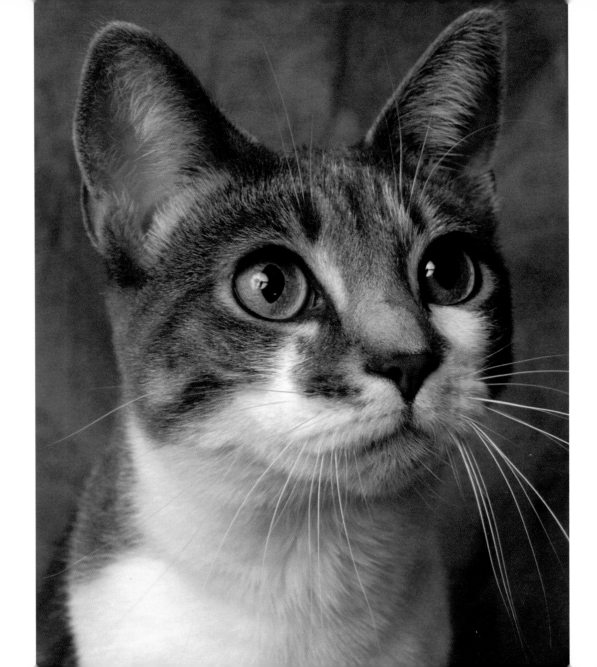

short hair,
||||||||||||||||||||||||||||

washing,
preening,

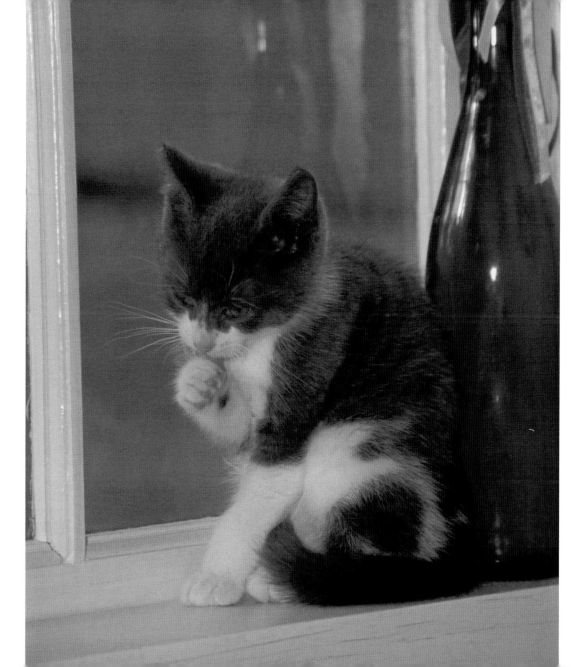

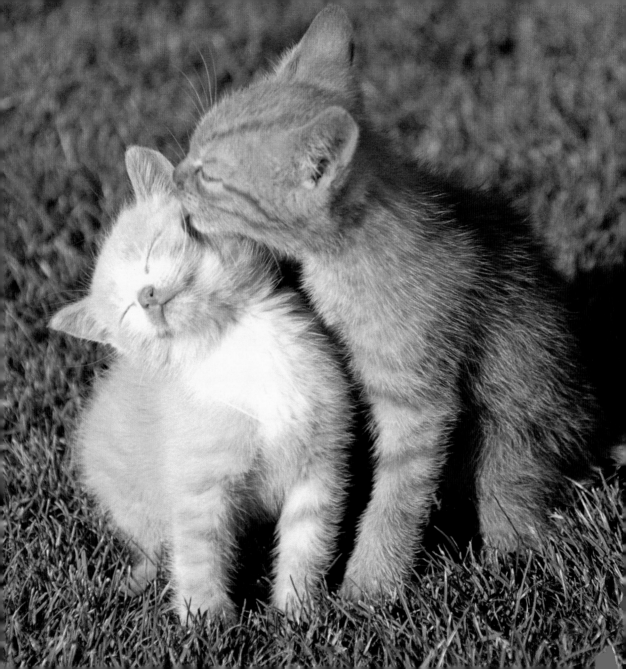

little
kittens
always
cleaning.

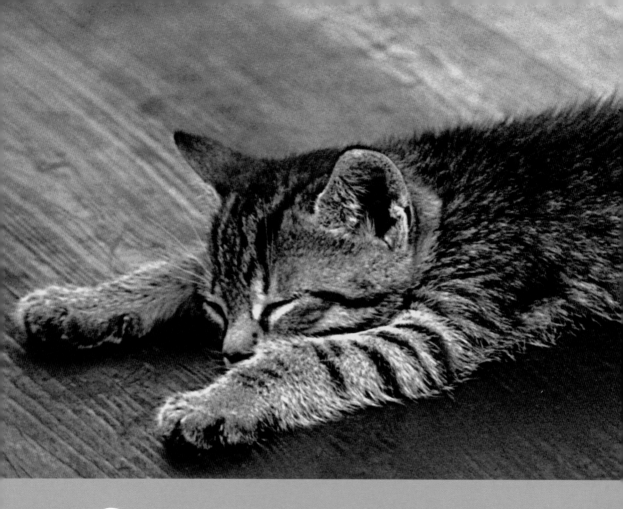

Stret

ching,

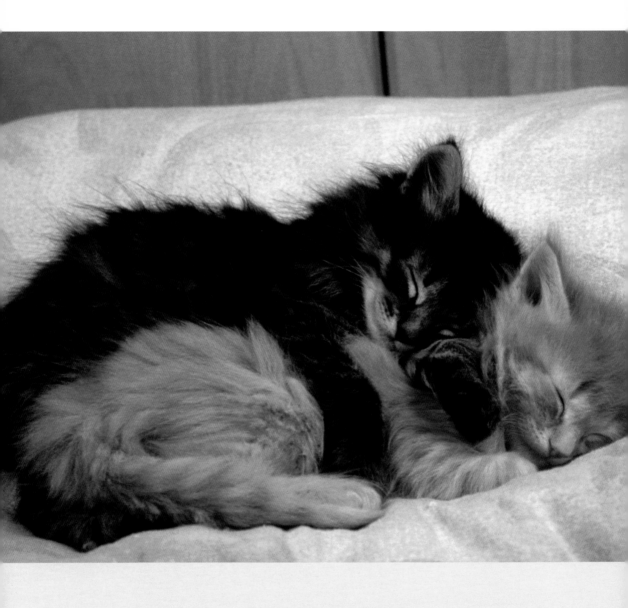

cuddling,

BATTiNG
paws —

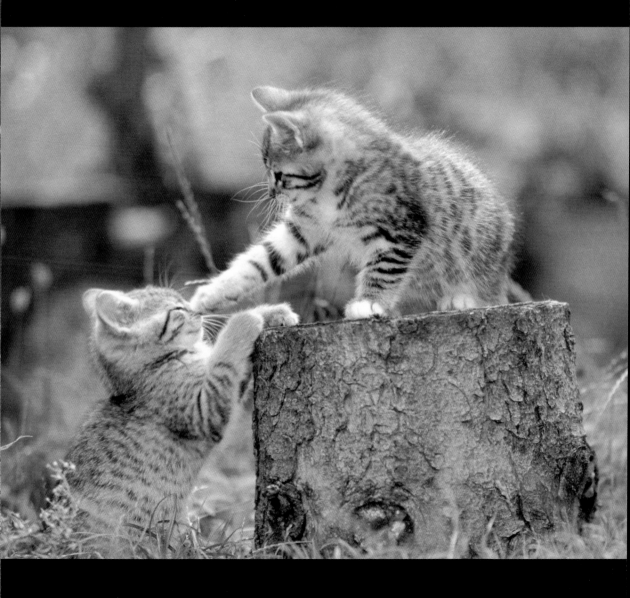

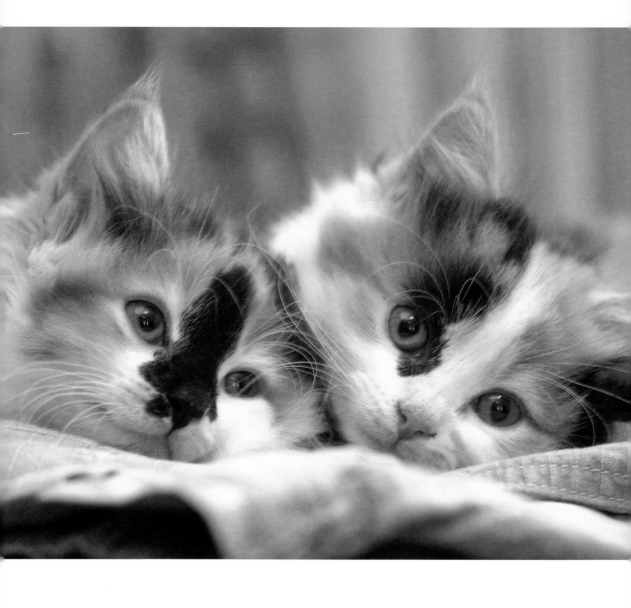

it
sometimes
seems
they have
no flaws.

Curled up tight and sound asleep,

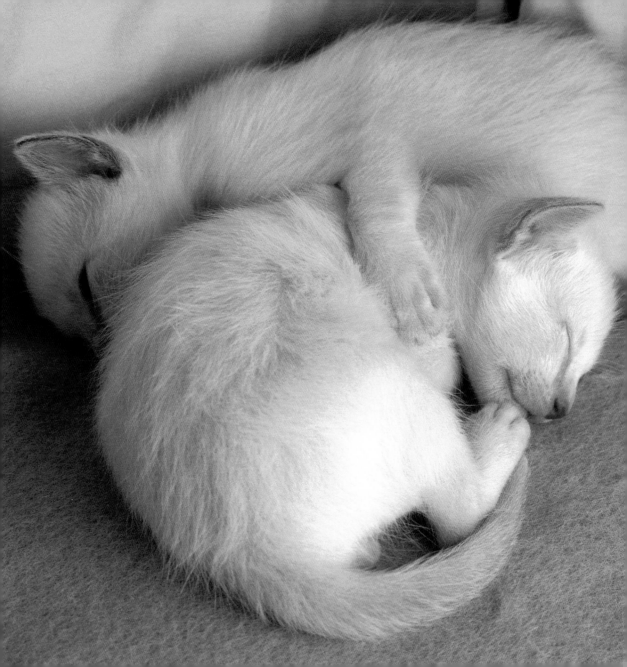

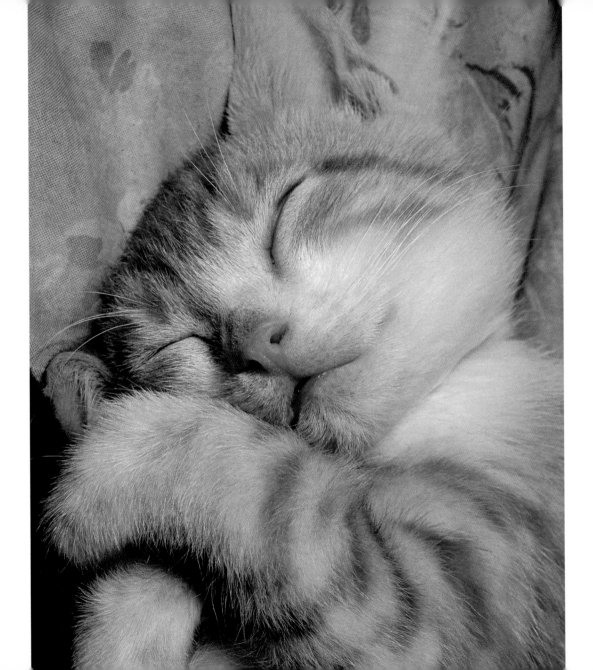

kittens
will not
make a
peep.

Inside,

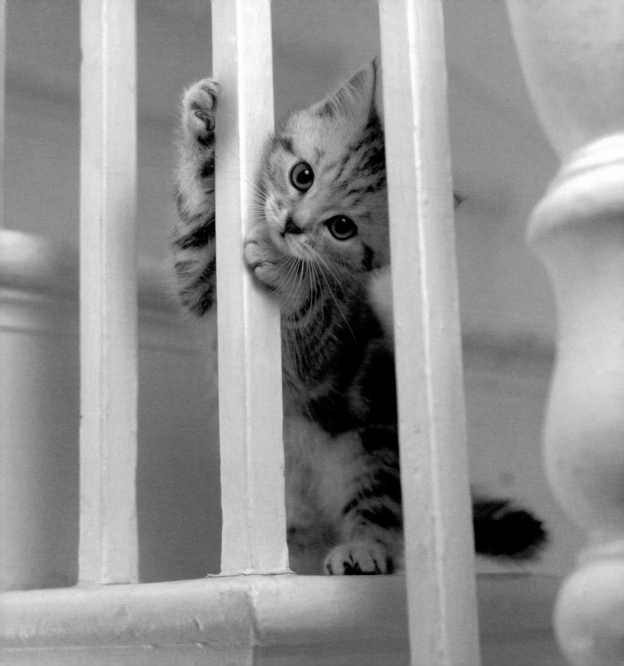

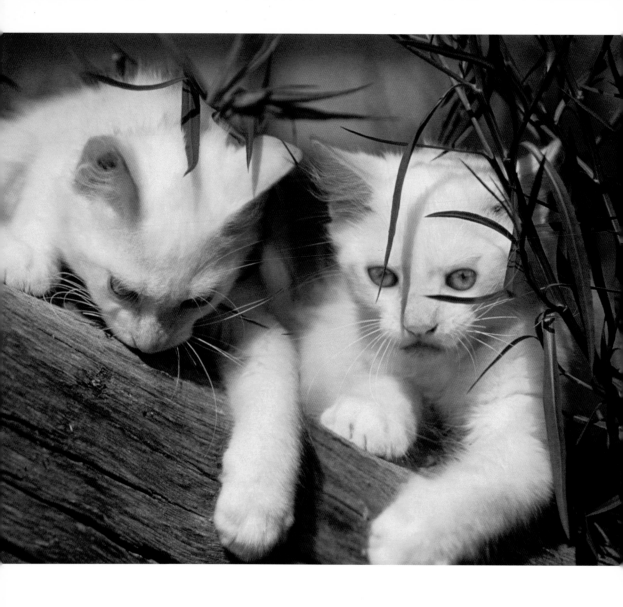

outside,

HIGH

or

LOW,

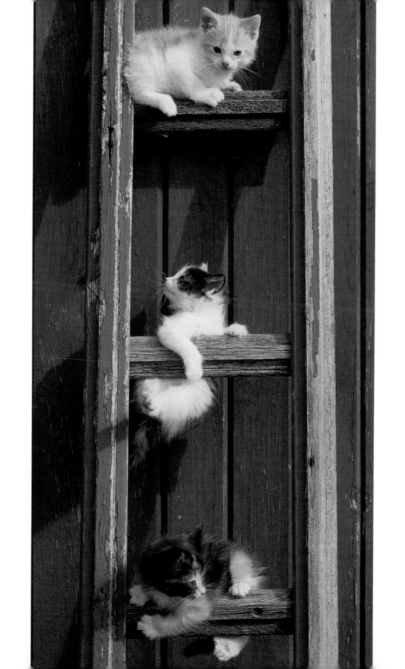

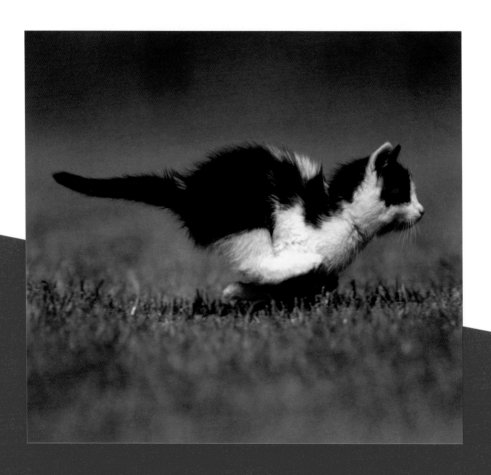

little kittens GO, GO, GO!

Kittens make amusing pets,

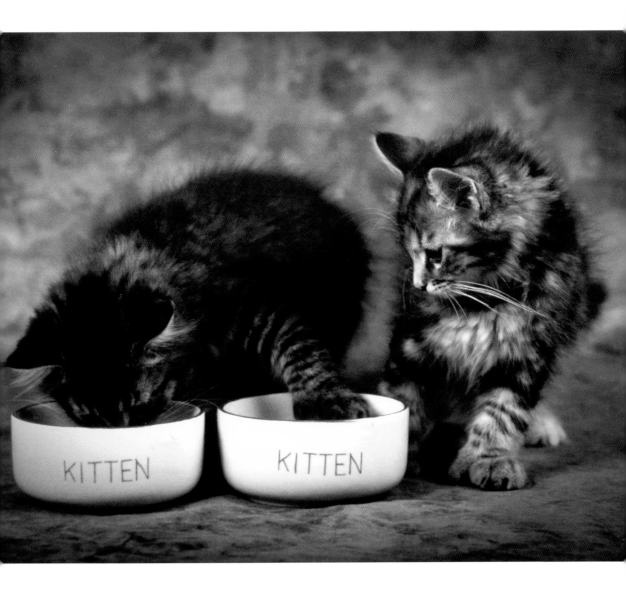

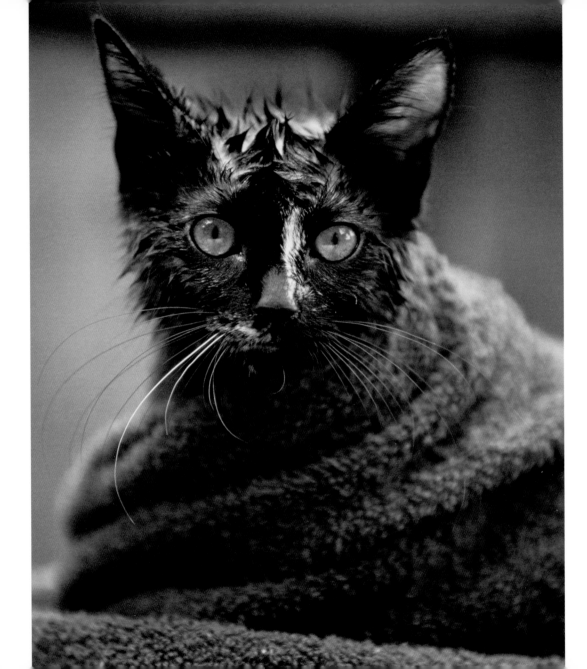

but aren't
too happy
when
they're wet!

Hunting,

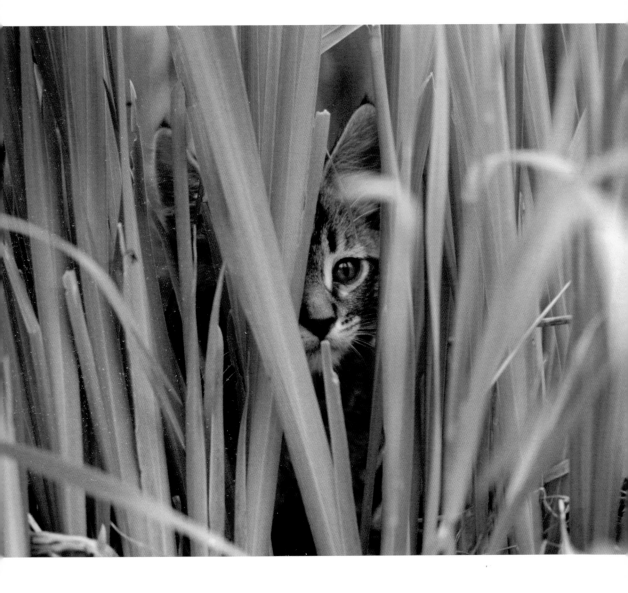

hiding,

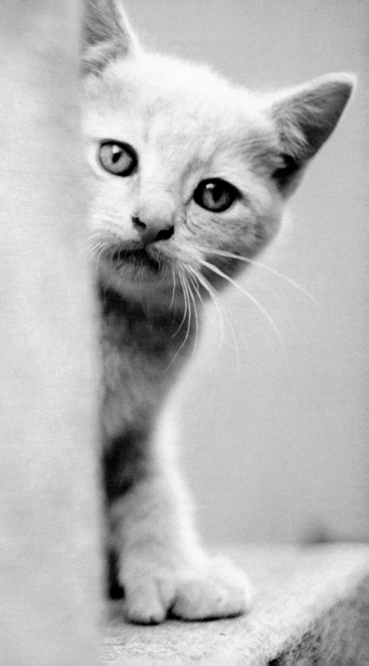

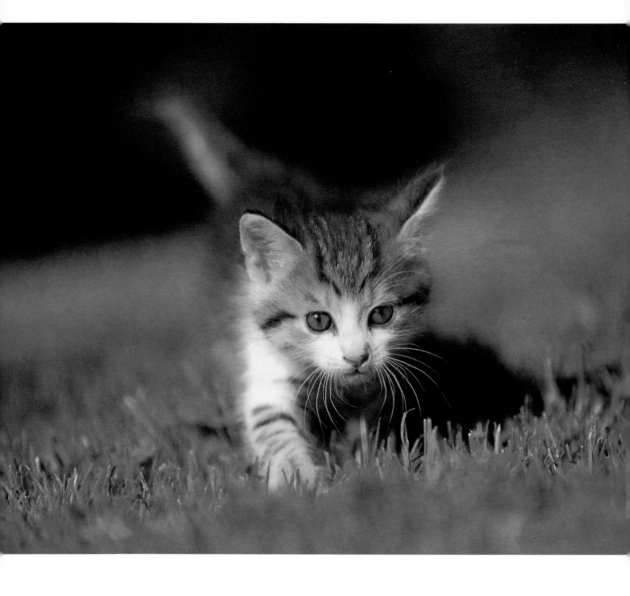

stealthy stalking,

sometimes
little
kittens
talking.

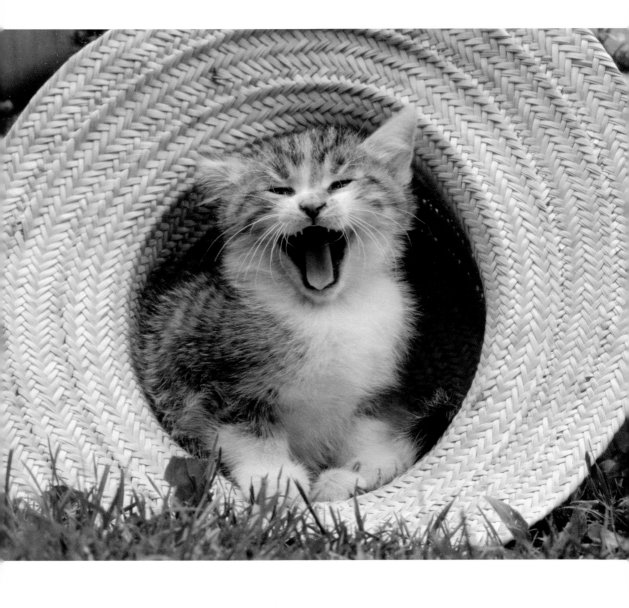

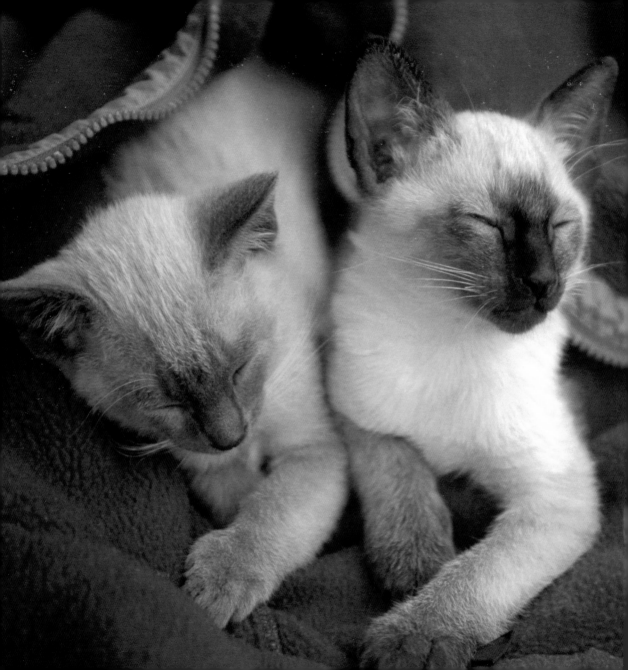

Kittens, kittens
all around,

kittens everywhere.

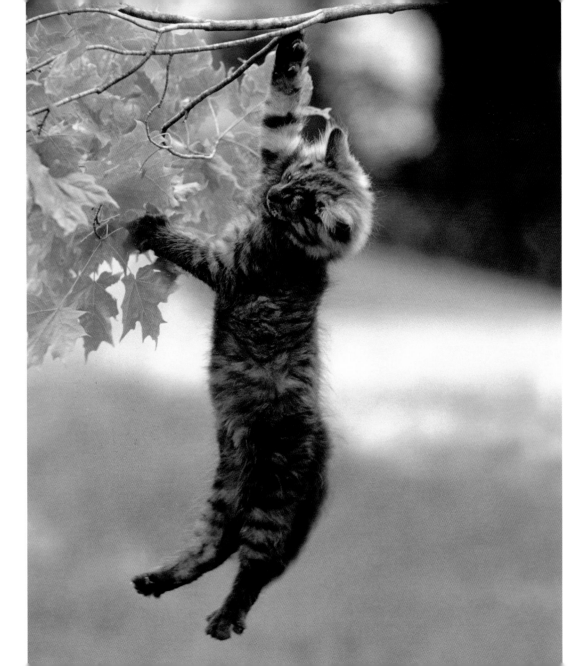

Curious
hearts

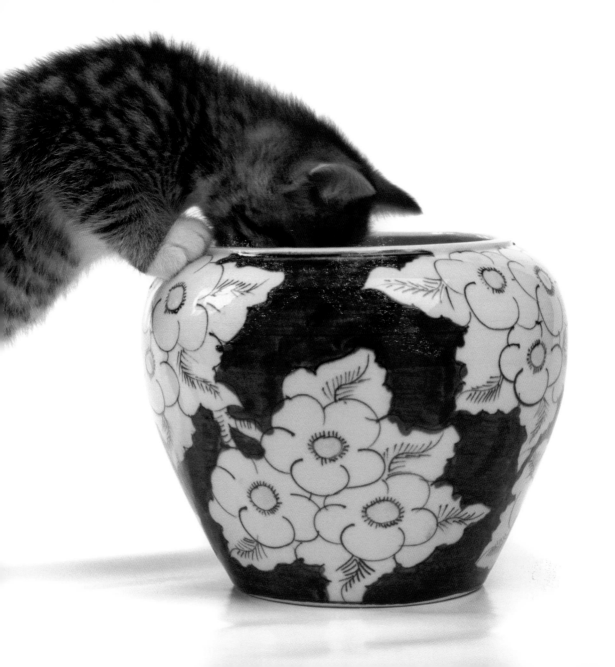

so small

and

sweet,

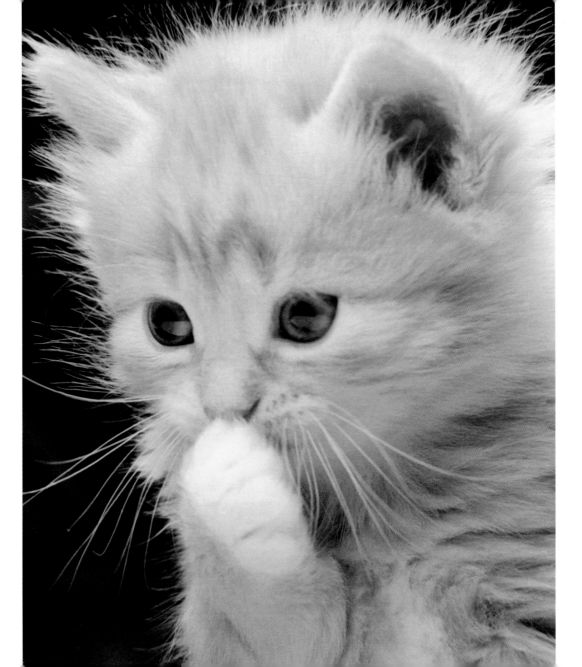

no
other pets
COMPARE.

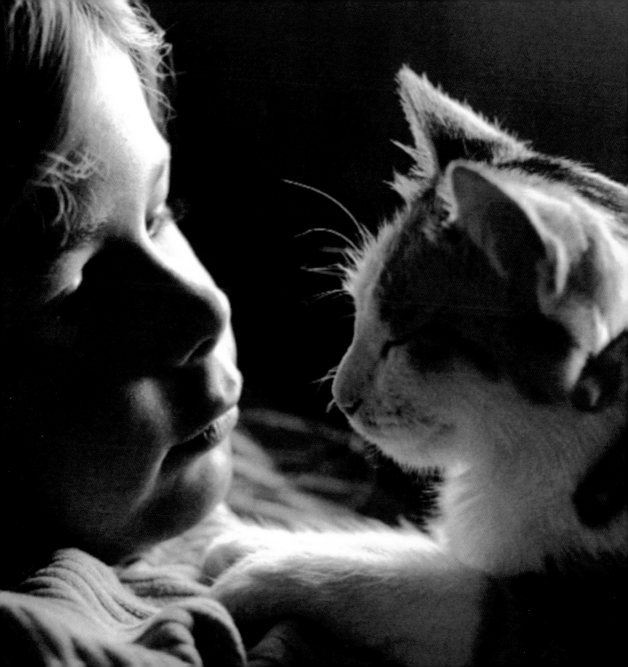